Christopher
Wren

The Avian Architect

Schiffer
Publishing Ltd

4880 Lower Valley Road, Atglen, Pennsylvania 19310

Meet a wondrous wren named Christopher,
A bird of no humankind fame.
Yet he is a giant in bird circles,
Building homes every chick wants to claim.

Like most wrens, this one was prolific,
Building many abodes in the spring.
Yet this bird employed more than sticks,
Each home was a wondrous thing.

Christopher's father was a great figure;
Leonard Wren had a wonderful knack.
An energetic builder, he was a fine filler
Of every conceivable shack.

Leonard Wren

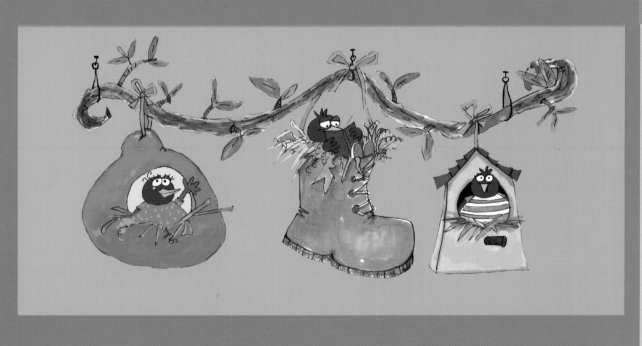

He used sticks and things that he found
To line boxes and hollow tree nodes.
He stuffed gourds, and holes in the ground,
For a multitude of starter abodes.

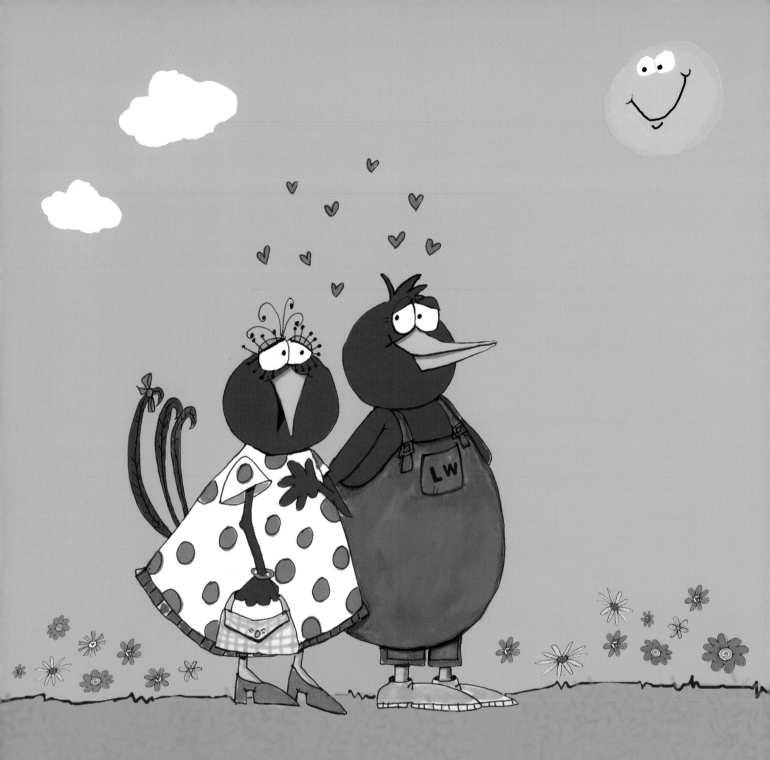

His heart yearned for a hen named Wendy,
A beauty with beguiling eyes.

She sought a home that was trendy,
And Leonard's work she was quick to surmise.

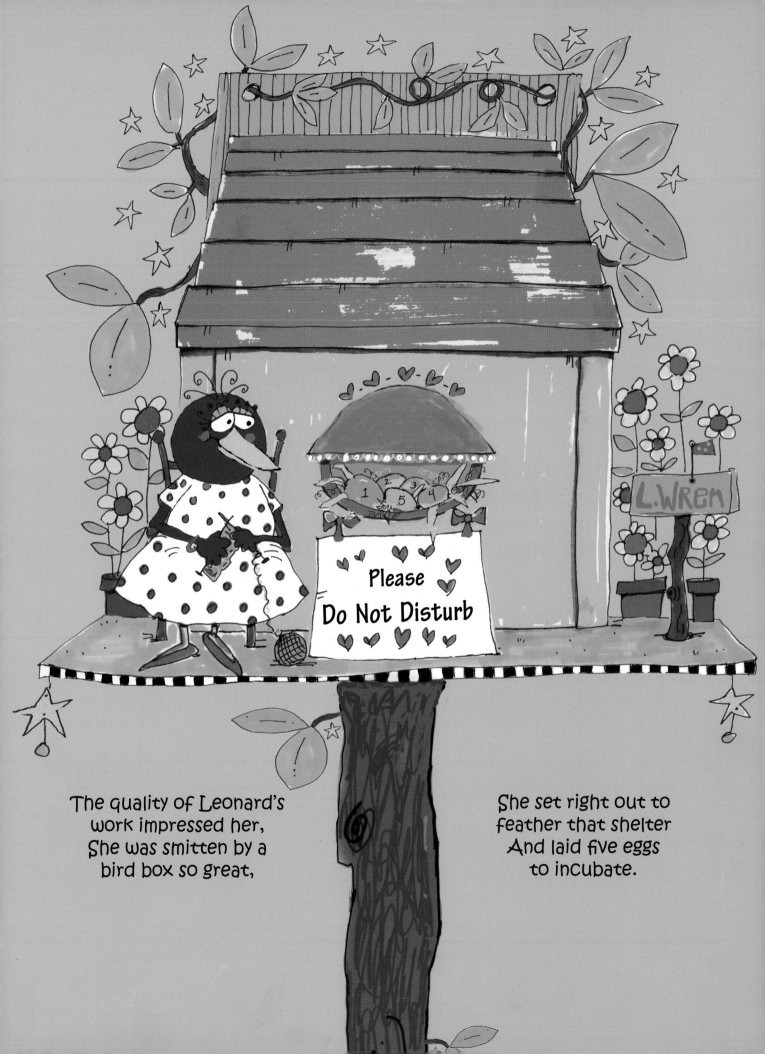

The quality of Leonard's
work impressed her,
She was smitten by a
bird box so great,

She set right out to
feather that shelter
And laid five eggs
to incubate.

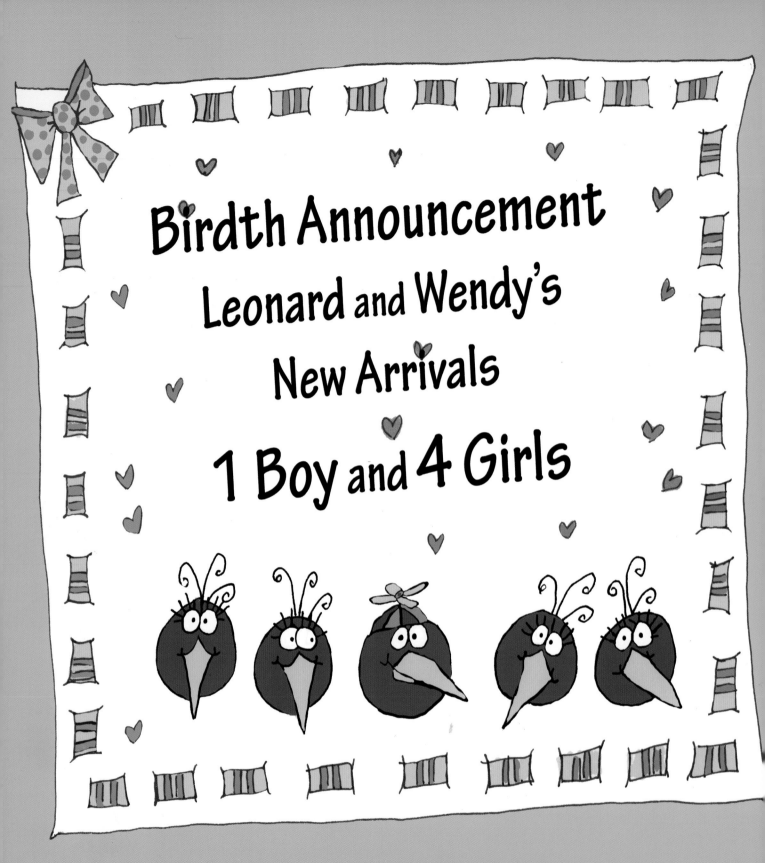

Birdth Announcement
Leonard and Wendy's
New Arrivals

1 Boy and 4 Girls

And so our Christopher was hatched,
A potbellied and featherless wee mite.
Wendy and Leonard were quickly attached.
For them it was love at first sight.

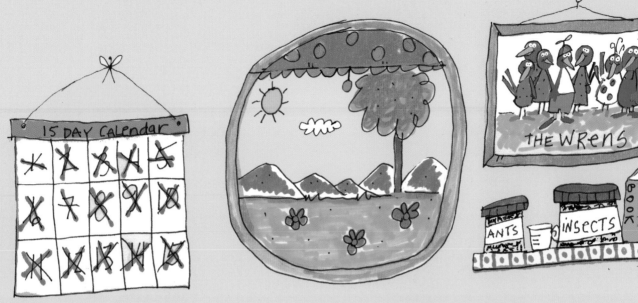

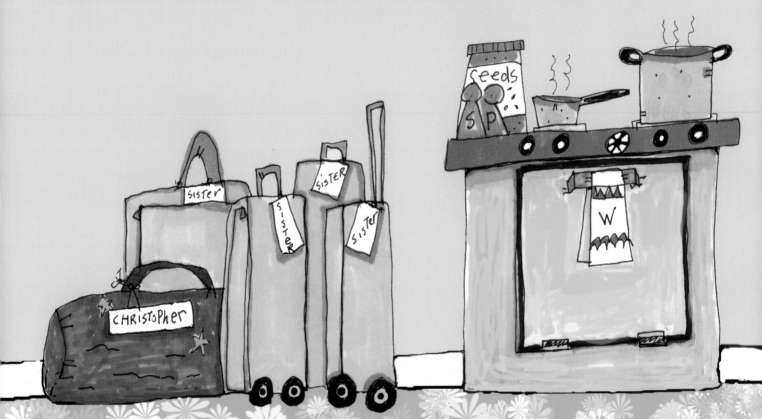

They nurtured their babies with zest,
Stuffing them with bugs and spiders
For fifteen days Mom and Dad did not rest;
After that those babes were outsiders.

Enjoying his first year as a bachelor,
Winging over forests and stream,
He only had eyes for architecture,
And he began to hatch his great dream.

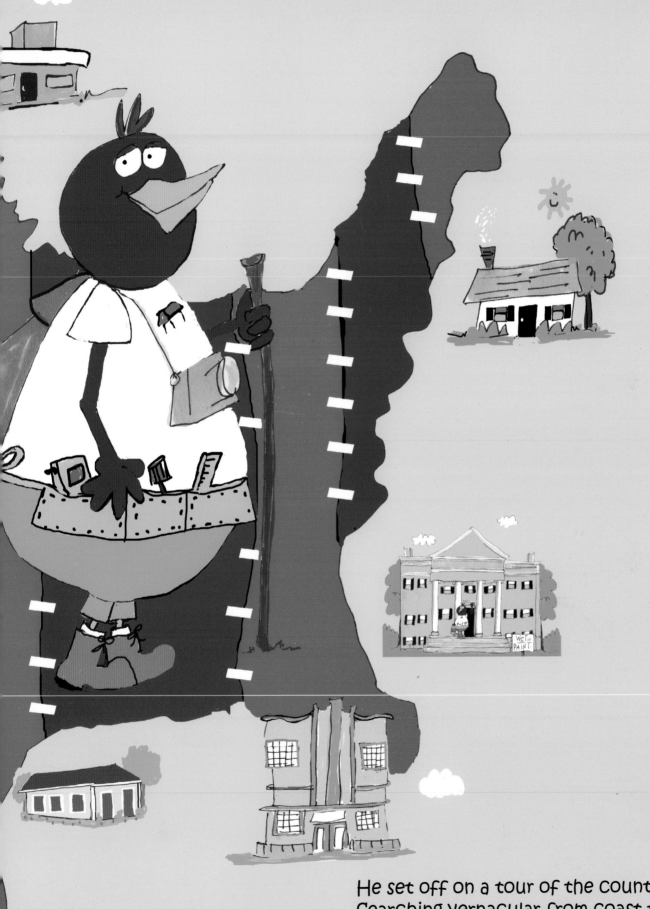

He set off on a tour of the country,
Searching vernacular from coast to coast.
From capes up north to contemporary,
He saw what each region could boast.

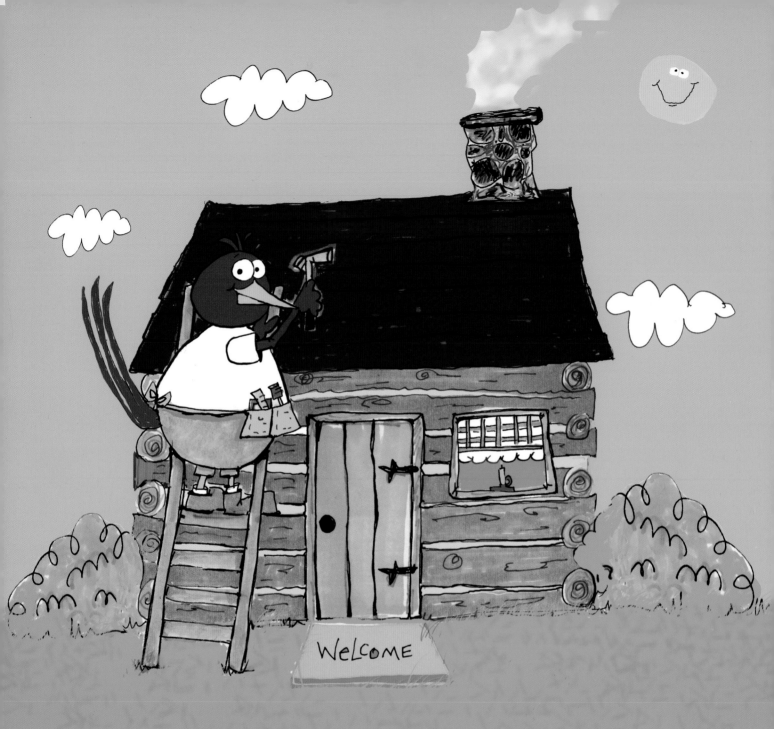

The next year, he embarked on his quest,
Something he'd been dying to do.

He wanted the ultimate nest,
Blending all he'd been exposed to.

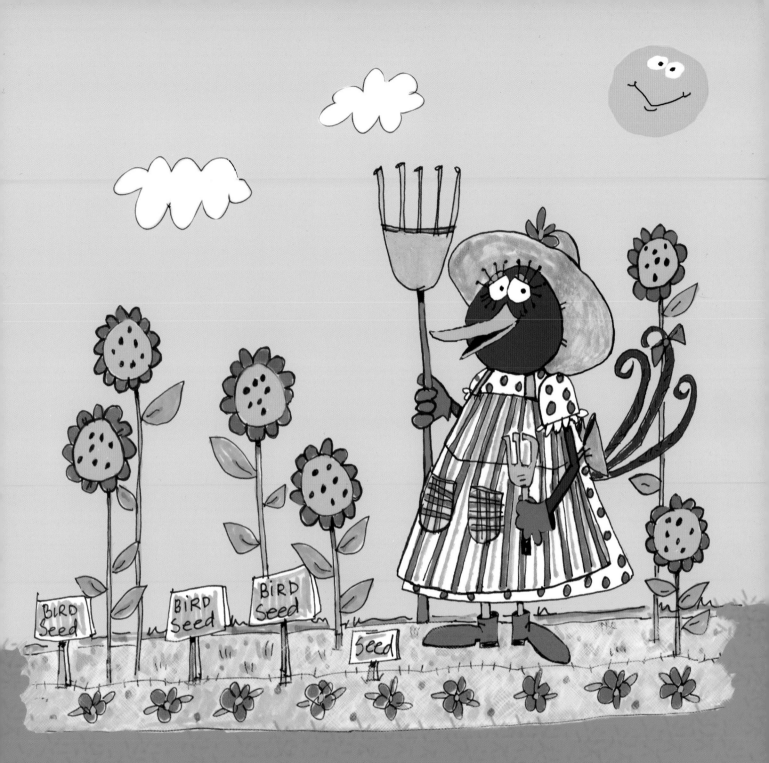

His first project was a log cabin,
Each log carefully dovetail jointed.

He used clay to chink the gaps within,
and as an architect he was anointed.

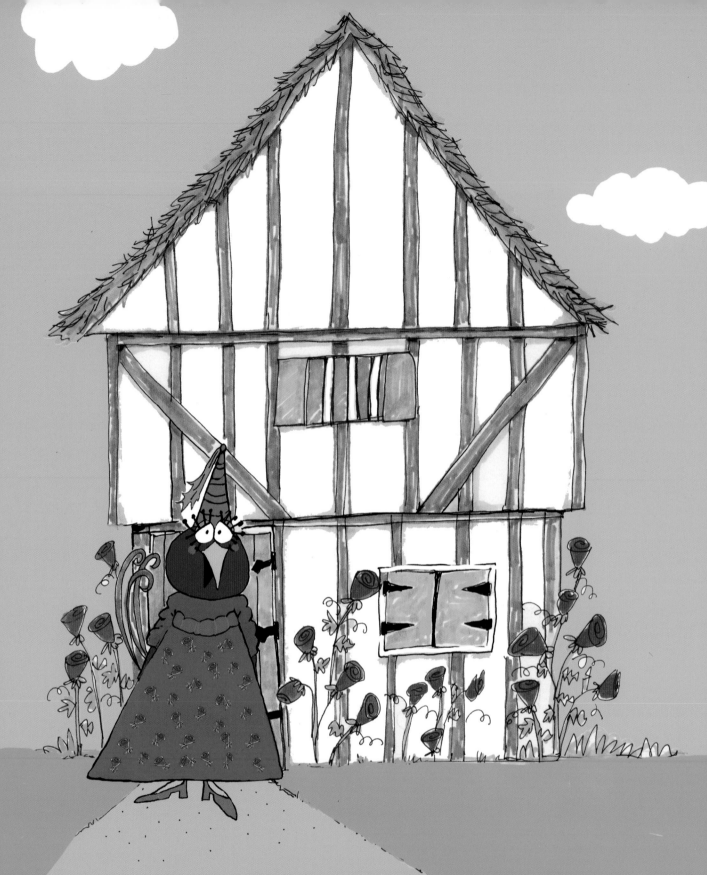

That home made Christopher want more;
A house to appeal to a snob.

He would build in the style of the Tudors,
Half-timbered with wattle and daub.

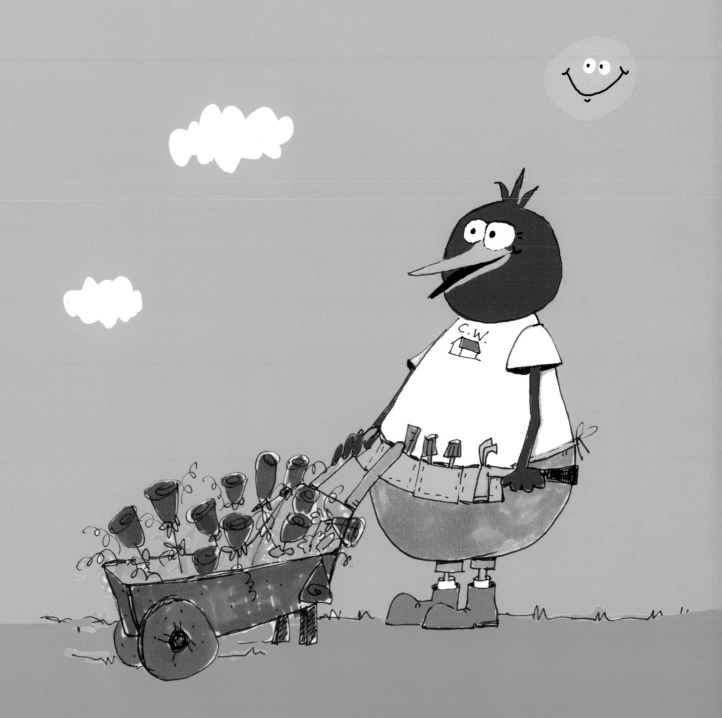

He topped the steep roof with thatch,
Above the cantilevered second floor.

This home most birds could not match,
But our Christopher still wanted more.

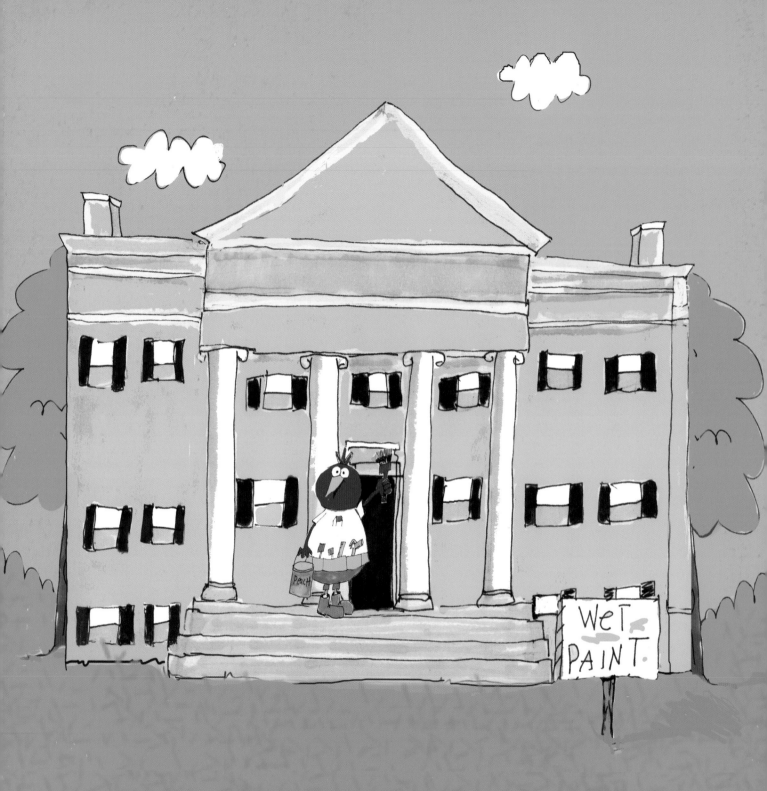

Georgian Revival was his next undertaking,
Evenly proportioned in every way.

It took much longer in the making,
But soon saw its opening day.

A doorway dominated the central third,
Flanked by windows arranged in foursomes.

What previous home crafted by a bird
Could sport a pediment, capitals, and columns?

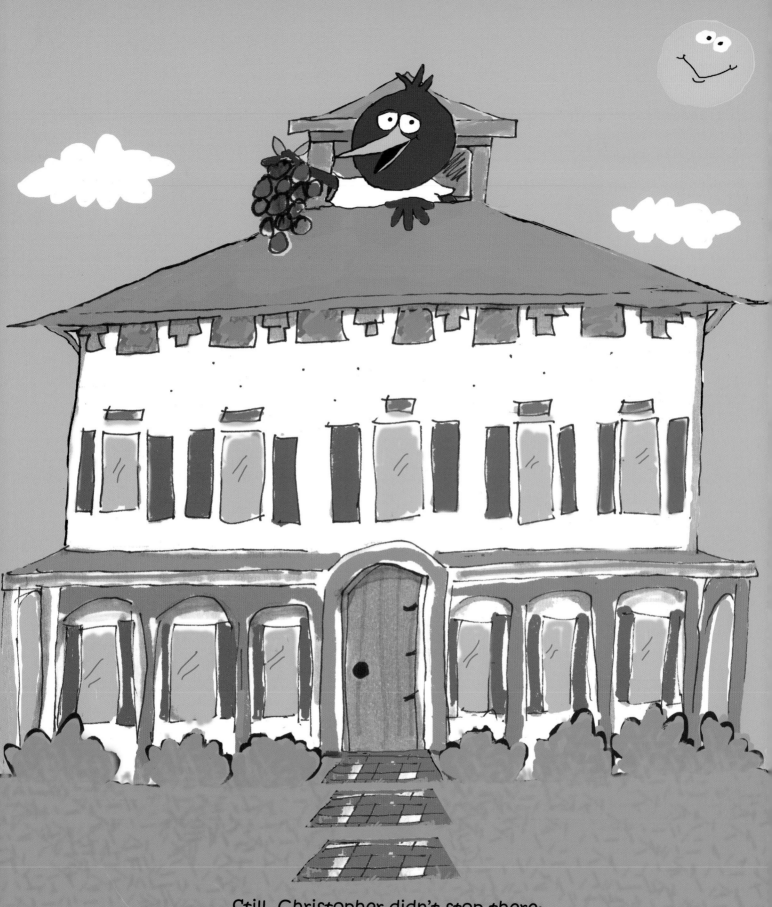

Still, Christopher didn't stop there;
He'd been struck by a building fever.
He built an Italianate Mansion with flair.
(This bird was an overachiever.)

Archways framed the rambling porch.
Elaborate brackets supported the roof.
A belvedere rose like a fine stately torch,
To his building skills physical proof.

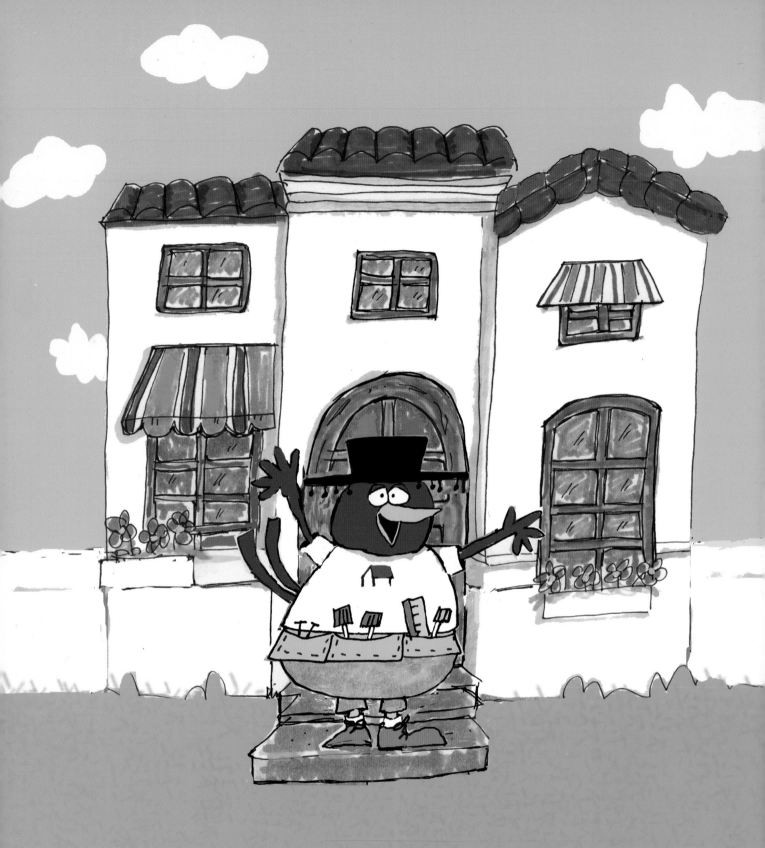

Then Christopher tried a new method,
Crafting Spanish Revival from stucco.

The freer form helped to fulfill him;
And red tiles on the roof made him loco.

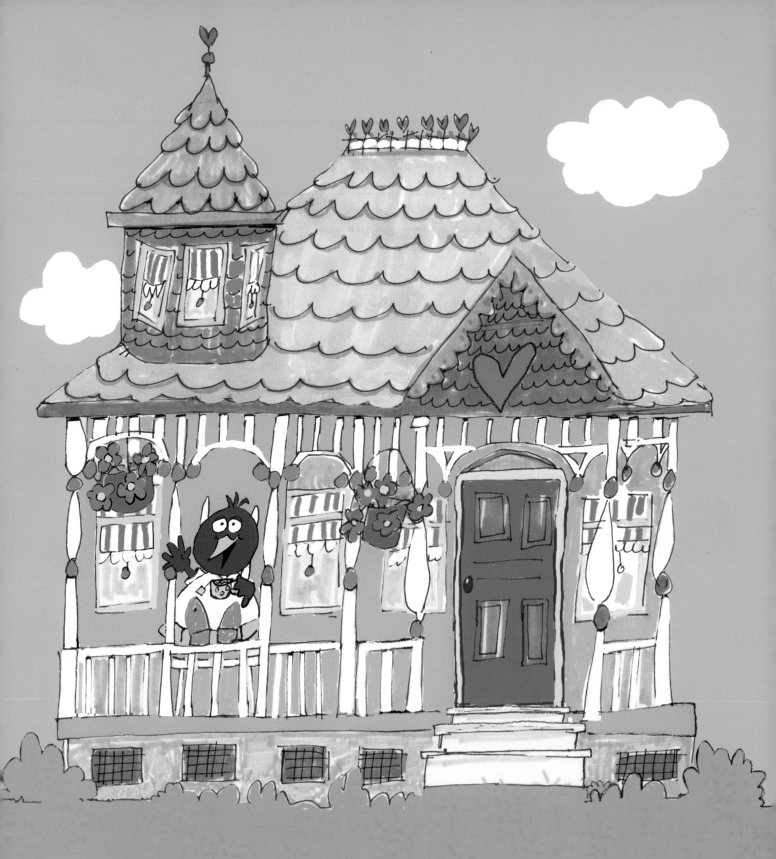

Inflamed by possibilities of pigment,
He draped a cottage in lacey woodwork.
This gingerbread gem was covered with tint.
(Perhaps he went a bit berserk.)

He took time and care in little details,
Like the finials cresting the roof top,
And spindles frosting the porch rails;
Work so sweet it could make a tear drop.

Appeased in his attention to minutia,
Christopher sought bold expression of hand

In forms free of extraneous hoopla,
A contemporary statement, a slash on the land.

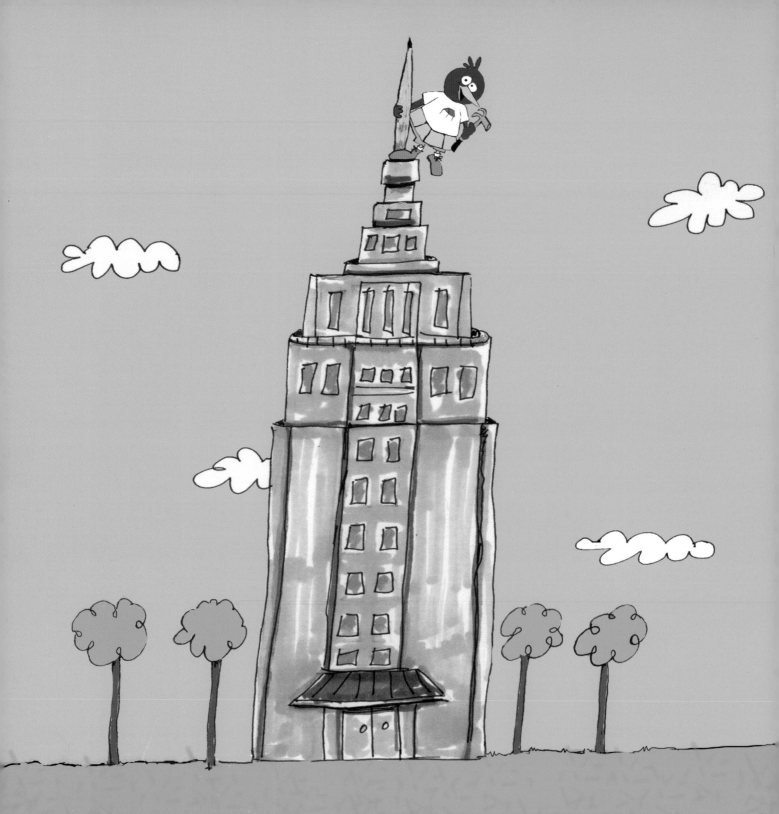

Excited by what he'd just wrought,
Christopher elevated his art even higher.

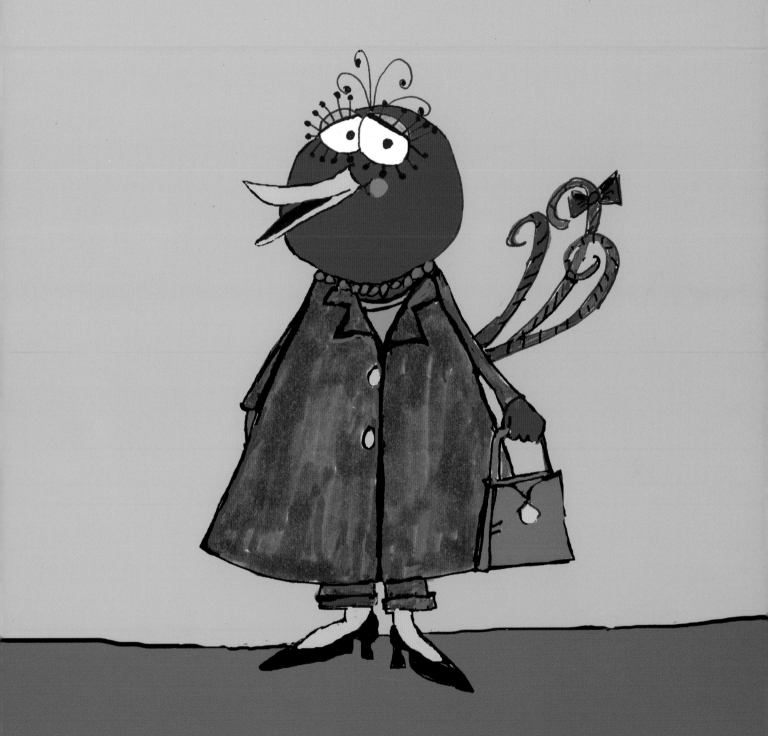

Filled with stylish Art Deco thoughts
He built a monument to the flier.

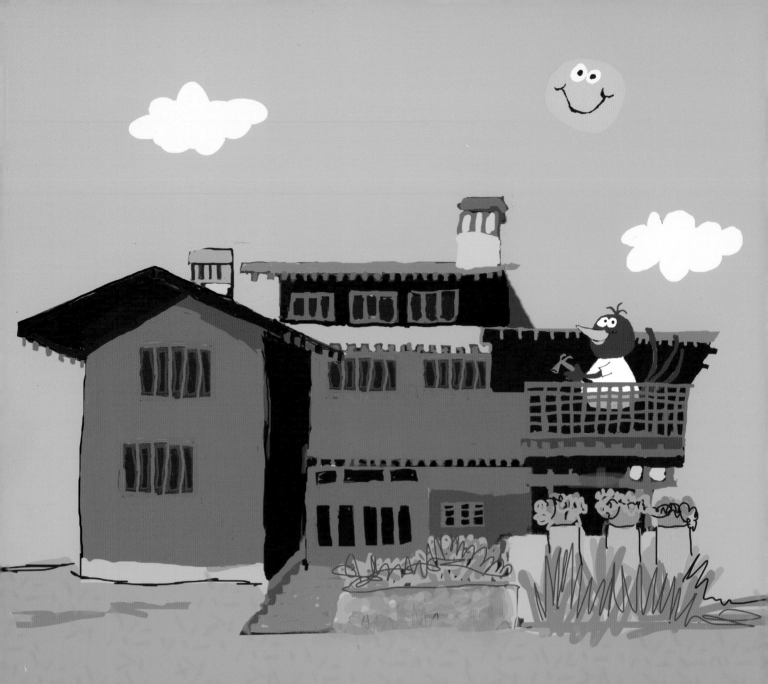

Enriching though these projects were,
Christopher set out on a new trail,
Seeking closeness to Mother Nature
With a bungalow made to bird scale.

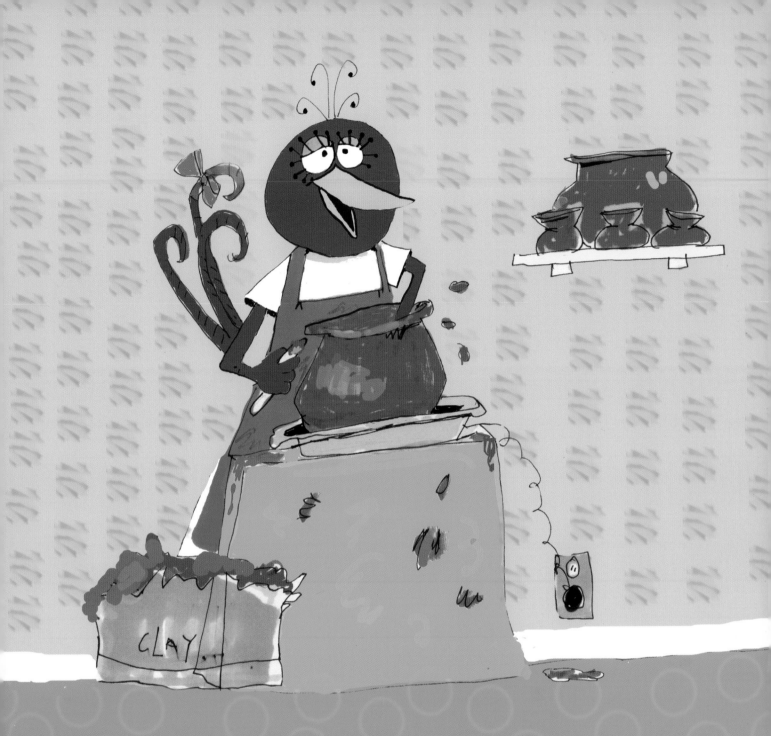

He based it on a home quite beguiling
Sighted on a pass through an L.A. suburb
A masterwork of Arts and Crafts styling
Of earthen tones and workmanship superb.

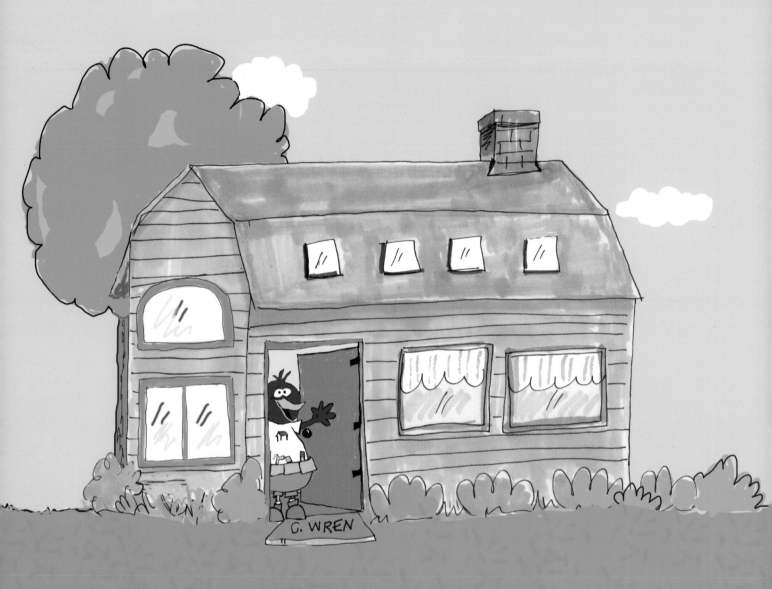

So relaxing did he find this fine dwelling,
He hung a shell on timbered post and beam.

Inside the possibilities were beyond telling
And Christopher hatched a new dream.

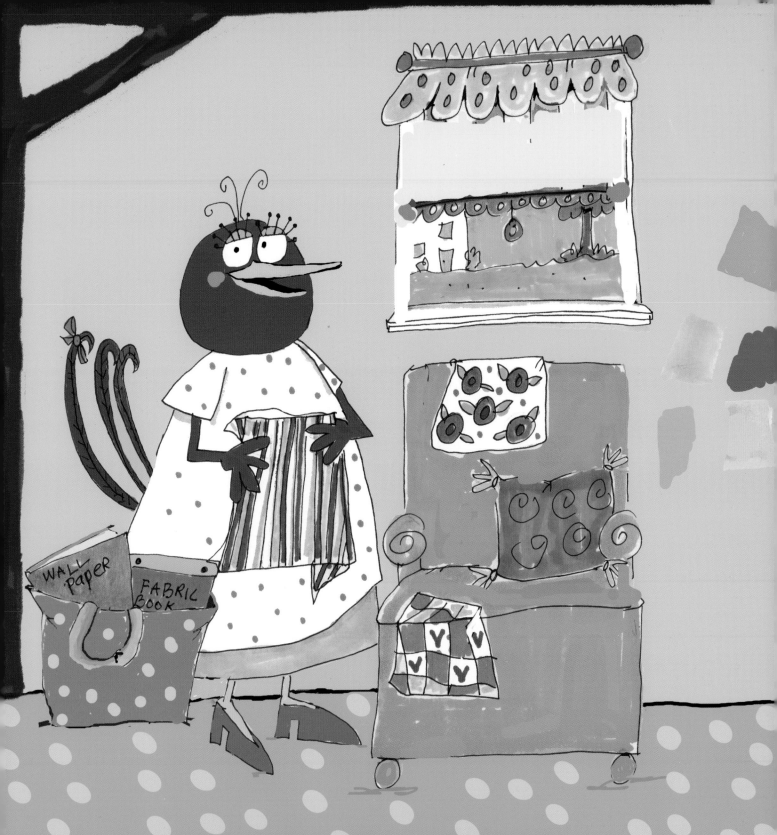

Beneath that gambrel roof of his making,
Was an interior so wide and inspiring

That it invited interior decorating;
A new skill for our bird to start trying.

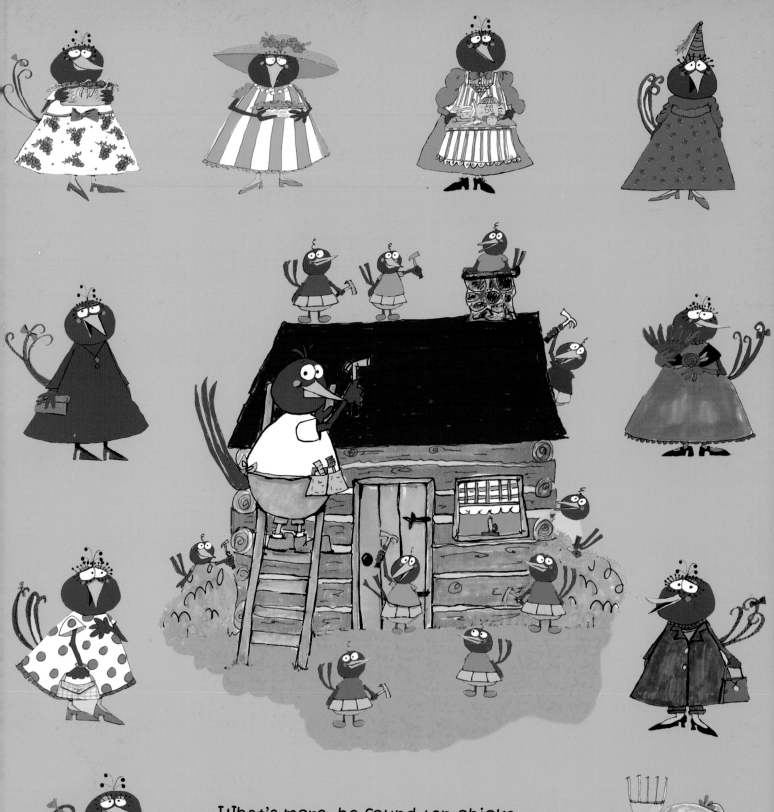

What's more, he found ten chicks,
All lined up to do his domestic bidding.
They furnished those ten homes with sticks
Then laid eggs and got to work sitting.

Raising budding architects was the best,
As each was a bright willing pupil,
Christopher gladly put them to the test,
Building homes without any equal.

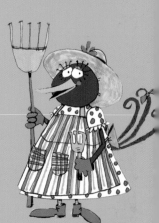

Notes and Discussion

About Birds

Male wrens start many nests each spring. They do this, in part, to give their mates a choice in the matter of which one to finish off and fill with eggs. They also do this to discourage other birds from nesting in the area by laying an early claim to all the best places. For this reason, they are despised by many bird lovers, who prefer bluebirds in their boxes instead of wrens.

After wren eggs hatch, the babies go from helpless creatures that can't lift up their own heads to fully fledged fliers in a matter of fifteen short days. (Fledged means feathered.)

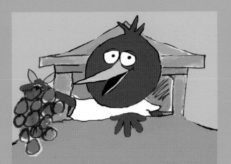

What is another word that means "home?" How about if you're a bird? (abode, house, shack, dwelling, building, shelter, haven, domicile, household, lodging, place, residence, den, habitation, nest, environment)

What kind of building materials can birds find in nature to use in building houses? (sticks, grass, straw, mud,...) What kinds of things do people use? (sticks, mud, grass, clay, brick, ...) How are our houses alike? How are they different? How long do wrens live in their houses? How long do people live in their homes?

About Buildings

Parents: The architectural terms used in this book are accurate. Spending time helping children identify the "big" words in the pictures is a good way to introduce them to architecture. The following are some ideas for discussion connected with some of the different house styles illustrated. After reading the definition, ask your child to find the right picture and then discuss the elements.

The pioneers built **log houses** when they first came to America, using entire trees and stacking them. They would notch the ends of the logs so that they interlocked. One way they did this was with triangular "dovetail" joints. Between the logs they would use clay or mud to "chink" the spaces in order to cut down drafts and make the home cozier.

Tudor houses are reproductions of the homes built by the aristocracy in England during Queen Elizabeth's reign in England and throughout Germany. Trees were felled and split in half (half-timbered) and these beams were used to form the shell of the house. In between, a mix of sticks, straw, and mud were used to fill the large gaps (wattle and daub). In olden days, roofs were often topped with cut grasses bound together to form a thick protective layer called "thatch." These roofs were great homes for birds and insects, and of course the grasses got wet and rotted over time, so roofs were replaced every few years. In this style of house, it was popular to build a larger second floor than the first, so the second floor was "cantilevered" out over the first story, and supported by brackets.

Based on ancient Greek building styles, the **Georgian Revival** home is generally perfectly "proportioned." The door would probably be in the center, with an equal number of windows on either side. Large "columns" in the front supported the roof, crowned by fancy "capitals." A triangular "pediment" was popular as a cap for doorways and windows. Everything is symmetrical, or balanced. Have your child point out symmetrical features of the Georgian Revival house, or on their own face!

Italianate style homes were very popular in the early nineteenth century, copying classical styles from Italy on new homes. They often featured "archways" and broad verandahs or porches. Their flat roofs were sup-

ported by brackets or triangles that braced against the outside wall and held up the roof's overhang. A belvedere is a fancy little viewing tower or pavilion that provides a rooftop view and allows light into the interior.

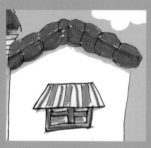

Spanish Revival brings the building traditions of Spain to the New World, and is distinctive because of the stucco, or plaster finishes on the outside. Spanish Revival styles often have rounded walls instead of sharp corners. Although we usually think of tile as something you find on the bathroom floor, rounded red clay roof tiles are also a distinctive feature of Spanish architecture.

During the **Victorian** era, new woodworking technology made fancy "scrollwork" or "gingerbread" widely available. The homes of the early nineteenth century tended to have lots of this fancy woodwork, as well as lots of color fitting for this lacy finery. Finials are little spires that stick up from the roof, and spindles are the pieces of wood that fill in a porch railing and generally look very decorative on a fancy cottage.

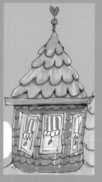

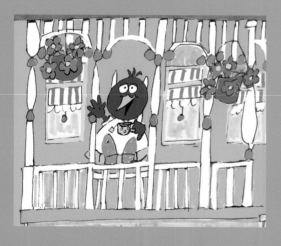

Art Deco was popular in the 1920s, and is characterized by simplified forms and straight, "streamlined" lines.

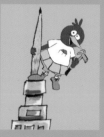

Arts and Crafts Style was very popular in the 1930s. It is the opposite of Victorian in that fancy was frowned upon. Instead, the homes were marked by simplicity and master workmanship, as well as natural materials and colors. Name some earth tones (brown, green, gold, blue, tan…)

A **timber frame** is a building built on a framework of post and beams, creating big open spaces like barns, where interior walls are not necessary to support the roof, and therefore are optional.

Discussion and Activities

Look at the little pictures on this and the previous page and try to find the house they come from in the story.

Interior is the opposite of Exterior. What are some of the things you use when you decorate a house inside? (paint, wallpaper, rugs, curtains, furniture,…).

What do you use when you decorate outside? (paint, shutters, columns, woodwork,…)

What kind of house do you live in?

Can you name five architectural elements or parts of your house, inside and outside?

Draw a picture of the house you'd like to build someday.

Go out and look at houses in your area. What style are they?

Buy an inexpensive bird house at a craft store and decorate it. Can you draw architectural details, like windows, columns, and gingerbread? Hang it outside in early spring. What kind of bird moves in?

Copyright © 2009 by Schiffer Publishing, Ltd. & Lou Marshall
Library of Congress Control Number: 2008934052

ISBN: 978-0-7643-3169-5
Printed in China